GAIL NIEBRUGGE'S

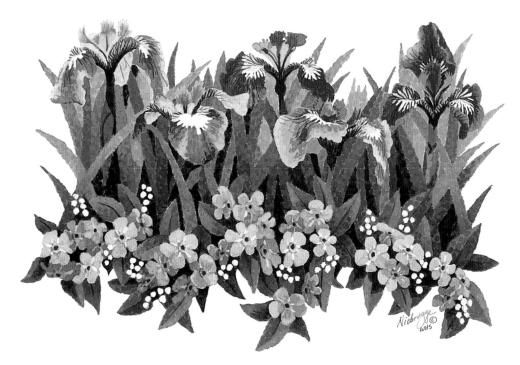

Alaska Wildflowers

AN ARTIST'S JOURNEY IN PAINTINGS AND PROSE

EPICENTER PRESS

DEDICATION

To Bob, my childhood sweetheart

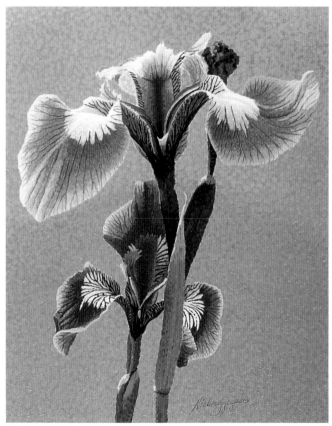

Wild Iris 14" x 20" acrylic

Epicenter Press is a regional press founded in Alaska whose interests include, but are not limited to, the arts, history, nature, and diverse cultures and lifestyles of the North Pacific and high latitudes. Epicenter seeks both the traditional and innovative in publishing high-quality nonfiction books and contemporary art and photography gift books.

Publisher: Kent Sturgis
Editor: Marcia Woodard
Text and cover design: Elizabeth Watson
Proofreader: Sherrill Carlson
Printer: C&C Offset Printing Co., Ltd.

Original and limited edition artwork from Gail Niebrugge may be purchased at our website, www.epicenterpress.com.

To order extra copies of GAIL NIEBRUGGE'S ALASKA WILDFLOWERS, visit www.epicenterpress.com or mail $16.95 plus $4.95 to Epicenter Press, Box 82368, Kenmore, WA 98028. Washington residents add $1.47 for state sales tax. You also may fax your order to (425) 481-8253 or phone it toll-free to (800) 950-6663, Visa, MC accepted.

Booksellers: Retail discounts are available from our trade distributor, Graphic Arts Center Publishing®, Box 10306, Portland, OR 97210.

First printing September 2000
10 9 8 7 6 5 4 3 2
PRINTED IN HONG KONG

Front cover: Prickly Rose, see page 30. Back cover: Triptych, see page 25.

Title page and front cover flap: Iris and Forget-me-not, 14" x 18" acrylic.

Hiking MacColl Ridge

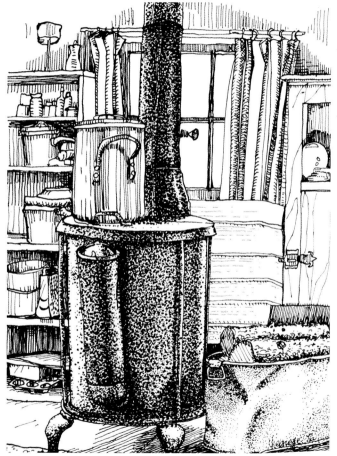

closely. The shift in focus began a new period of discovery for me that has enriched my artistic perspective forever.

Wildflowers are now my addiction—especially finding new ones and researching them; it's important to me that I become a student of my subjects. Our move to Palmer in 1995, where the weather is milder than Copper Center and wildflowers flourish, only enhanced the addiction. I've come a long way from referring to lupine as the "tall purple flowers" and cow parsnip as the "big green plant with the cauliflower-shaped blooms." The more I learn and the more I paint, however, the more I feel like I have only just begun.

Airtight 14" x 18" ink

restaurant. Occasionally someone would buy one, and the whole family would rejoice! I trekked through the woods and explored trails in our four-wheel drive, faded green International

Gail with "Charlie"

Scout and looked for the perfect vantage point. I learned to fly, bought a Cessna 170B in Kansas, named it "Charlie," and flew it home to Alaska. I explored from the air seeking the big picture: vast landscapes and wide vistas.

I painted the Alaska landscape for more than fifteen years before I looked down. One day I was immersed in what I call a complete French, postimpressionist, Seurat moment: I was visualizing and studying a meadow filled with thousands of brightly-colored wildflowers. My usual approach was to paint the flowers as colored dots against a background of various hues of green. To this day I still don't know what caused me to stop, look down, and examine an individual flower more

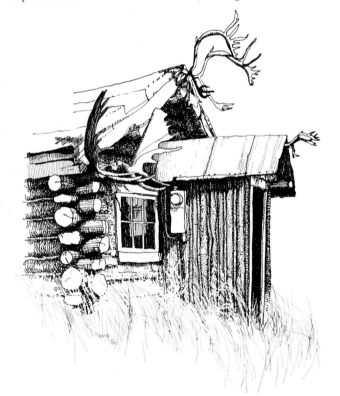

Caribou Cabin

20" x 24" ink

Gail at drawing board

*T*he method I use for most of my wildflower paintings is pointillism; it's not something I planned. In 1987, I had a lot of unexplained neck pain and headaches, I was diagnosed with Temporomandibular joint (TMJ) syndrome, and I underwent a long series of treatments. The TMJ diagnosis, however, turned out to be a mistake. Once my real problem was discovered, a dislocated jaw, I had successful surgery.

During the long period of recovery, I had to lie on my back for months with limited use of my arms. To keep my sanity, I needed to paint. Necessity is the mother of invention: Bob rigged up an easel over my head and, by placing the palette on my chest, and with the help of a mirror, I could manage it. My limited arm movement, though, meant I couldn't make the long, sweeping brush strokes or blend paint in the manner to which I had become accustomed. By slowly and carefully placing one dot at a time on the canvas, and resting my arm in between, the entire surface was eventually covered with thousands of dots. This technique of painting with dots is called "pointillism."

Through this experience, I learned that everything happens in its own time at its own pace: we are only along for the journey. In my case I was given a second chance to paint; it wasn't the way I wanted to paint, but a new way to paint. Through the grace of God, the unconditional love of an incredible man, and the support of two fine children, I'm living my dream. Please join me in the journey.

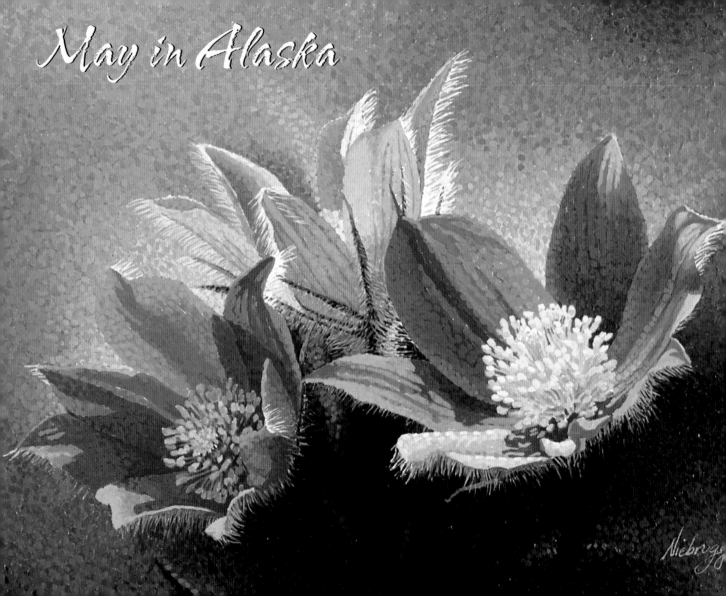

May in Alaska

During spring break up, the Canada geese arrive in great numbers and fly in and out of marshy fields to feed. I spend days traveling up and down the back roads watching these elegant waterfowl on their journey north. The patterns of melting snow, the intensely blue sky reflected in ice melt, and the textures of yellow grass against dark, thawing earth arouse winter-deadened senses.

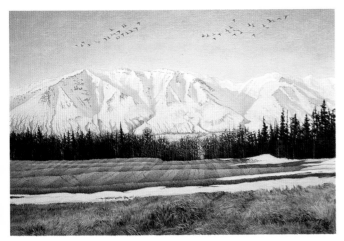

The Return 18" x 24" acrylic

◀ *Pasque, Spring Crocus* In May, the pasqueflower grows wild in the gravel berms and ditches on both sides of the Glenn Highway leading up to the town of Tok. They appear to have been planted as part of a "Welcome to Tok" beautification effort. 14" x 20" acrylic

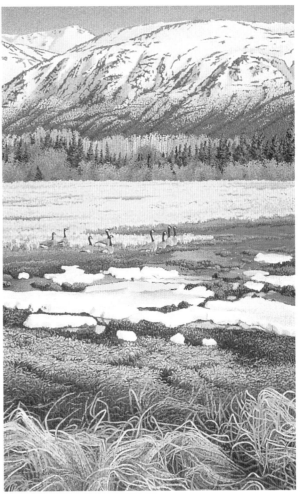

Spring Sojourn 15" x 24" watercolor/acrylic

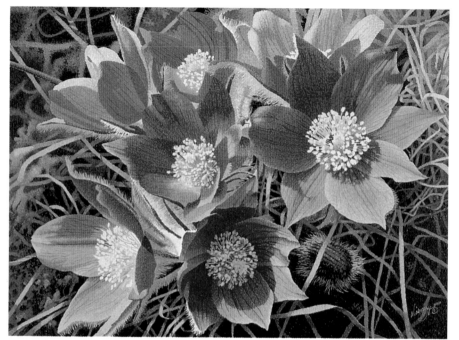

Crocus Cluster 22" x 30" watercolor/acrylic

▲ For nineteen years I lived in Alaska's Copper River Basin where winter lasts seven months and temperatures dip to sixty below zero. Each year as the snow thawed and the soil warmed into mud, I wondered if the wildflowers and vegetation would ever return. Each year my pessimism melted as tiny green shoots broke through the dirt. My excitement grew as I waited for the purplish-pink petals of the crocus to emerge, and I still feel giddy at the sight of first spring color.

▶ Lady slippers are hard to find in Alaska, and their whereabouts is knowledge coveted by people who love wildflowers. When I do find a rare treasure such as this, I remember lessons learned as a Girl Scout hiking the backcountry of San Diego County. We were taught to enjoy and admire the wildflowers but not pick them: leave them for others to see.

▼This group of crocuses take on personalities all their own. They remind me of the characters in *Snow White and the Seven Dwarfs*.

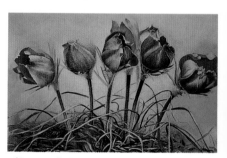

First Color 22" x 30" watercolor

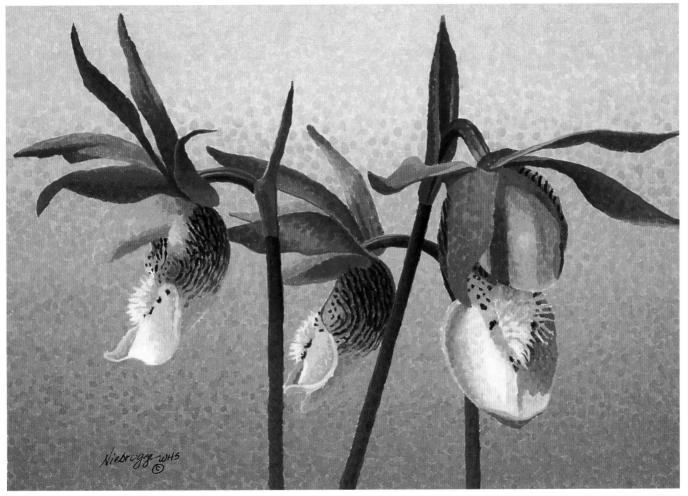

Lady Slippers

14" x 20" acrylic

Early June
Favorites

The Alaska State flower is the forget-me-not. For years I saw them painted on plates, post cards, and calendars, but I had never seen the real thing. One day I was determined to find one, so I took my Alaska wildflower field guide and climbed up and down hills and through meadows in waist-deep wildflowers; none of them looked like the pictures on the plates. Frustrated, I sat down and was almost buried by the tall foliage. Next to my boots were a bunch of itsy-bitsy blue flowers. Forget-me-nots! That was the day I discovered it's difficult to show how small forget-me-nots are in a painting.

▶ When I began to paint bluebells, I discovered many types of plants that have nodding, blue, bell-shaped blossoms. Chiming bells, the species represented in *Bluebells,* grow profusely along the road to Hatcher Pass. Along a rocky outcrop on the shores of Kodiak Island, I found the more delicate bluebells of Scotland. While hiking the stone slopes surrounding the Harding Ice Field above Exit Glacier, I found a tiny, upright, blue, bell-shaped flower called the mountain harebell. This wildflower thing can become a passion.

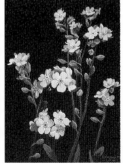

◀ *Forget-me-not*

(Detail at left) 14" x 20" acrylic

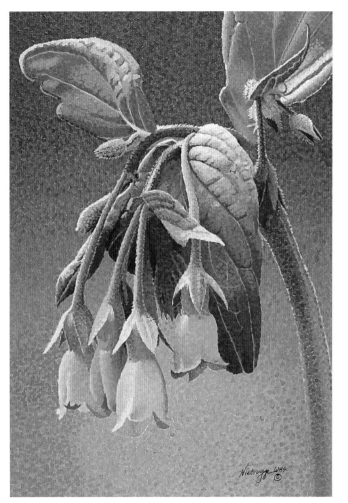

Bluebells 14" x 20" acrylic

▼ About the same time each summer that the yellow oxytrope bloom, Bob and I camp out for several days on the Gulkana River and fish for king salmon in our 12-foot raft. One year we decided to do it all in a twenty-four-hour marathon.

 We got off to a bad start: it was after midnight, pouring rain, and we were tense and tired. In twenty minutes, we knew we had a bad plan and headed for shore. The next thing we knew, the raft had slammed into the bank and the recoil somersaulted me into the river. We fell asleep that night with the knowledge that our trip was doomed. Eight hours later we woke up to the rare gift of warm sun and spent the rest of the day floating and observing nature and wildflowers.

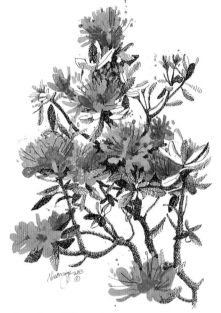

Lapland Rosebay 10" x 14" ink/watercolor

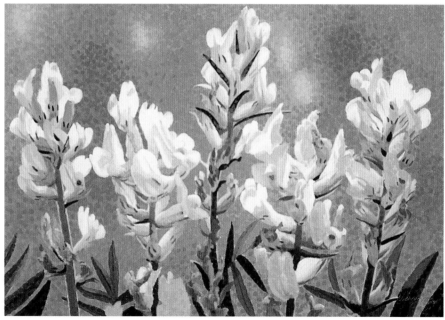

Yellow Oxytrope 14" x 20" acrylic

14

▼ On a remote fly-in trip with Bob, we pitched our tent in the midst of fields of yellow dryas. One afternoon while climbing a scree slope, I reached up to grab a ledge and came eye to eye with a black bear. I retreated hastily behind Bob, who had armed himself with a little red can of pepper spray. The annoyed bear advanced aggressively to within a few feet. Bob sprayed him. Looking back as we thrashed through the undergrowth, we saw two black ears—above the bushes—headed rapidly in our direction. During the next twenty-four hours while we waited for our plane, we took turns tending a big fire as the bear continually stalked us beyond the dark shadows.

◄ Before we moved to Alaska, I was an illustrator for the U.S. Navy and Marines and, later, a graphic artist for a school district with more than 1,000 teachers. Most of my artwork consisted of pen-and-ink line drawings and was in the form of cartoons; the military even had me doing cartoons for a training manual illustrating amphibious warfare. *Lapland Rosebay* and the other ink drawings in this book brought back memories of my days as an illustrator. Having avoided that medium for awhile, I was surprised by how much I still enjoyed it.

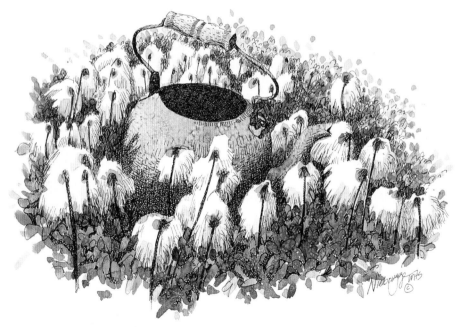

Yellow Dryas and Pot

10x14 ink/watercolor

15

▼ The public often mistakes my artwork for photography. I don't know if I should feel insulted or take it as a compliment.

I paint the summer with its riot of color because I've seen too much of the long, dark, white-on-white winter. In Copper Center, where the winters are much more cold and difficult than in Palmer (our current home), I would sit alone in my basement studio with the furnace cycling every ten minutes, the windows edged with frost, and rolled-up towels set along the door sills to keep the icy draft from my feet. I just couldn't muster the desire to spend days and days painting winter scenes.

It's not that working at home didn't have its advantages. While my husband and children commuted in ice fog and dealt with the

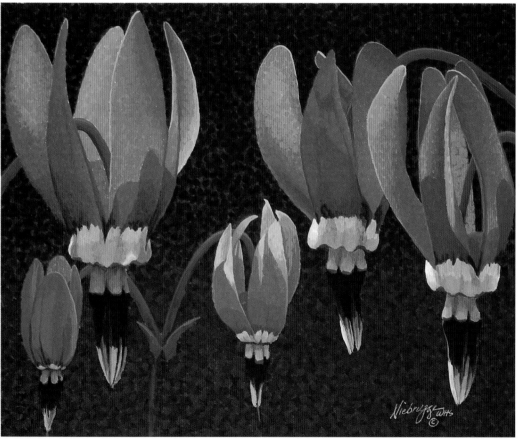

Shooting Star

14" x 20" acrylic

treacherous Simpson Hill, engine block heaters with frozen power cords that snapped in half, and frozen tires that clunked along for miles like blocks of wood, my morning routine consisted of making a cup of hot coffee, putting on my slippers and sweats, throwing another log in the wood stove, and contemplating a partially-finished canvas of wildflowers. Did I feel guilt? You bet I did.

I also felt like some kind of strange, goofy princess in comparison to many of my fellow Alaskans when my eight-hour day consisted of perfecting the center of a wild iris or painting the shadows of moose antlers on the front door of a cabin. Painting seemed particularly frivolous in the world of the Bush where people struggle every day with life and death, and, for example, getting a car started to take a kid to the doctor is an all-day project. When these same Alaskans honored me by saving up their money to purchase my art and hang it in their humble homes, it touched me so deeply that all I could do was cry.

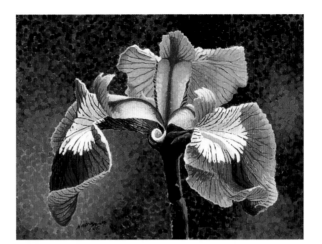

Showy Iris 14" x 20" watercolor/acrylic

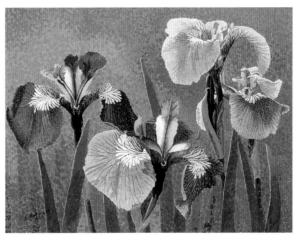

Four Iris 22" x 30" acrylic

◄ The tall stalks of the indigo-colored iris make it one of my favorite wildflowers. At first glance, these wild irises look like an army of small, blue, identical flags stuck in the ground. Closer observation reveals diverse blooms with distinct color patterns and irregularly shaped corolla. In early June, stadium-sized fields of this perennial, in purple, can be seen dominating the marshes along the Glenn highway near the Eklutna flats and brazenly splayed along the wetlands of Turnagain Arm.

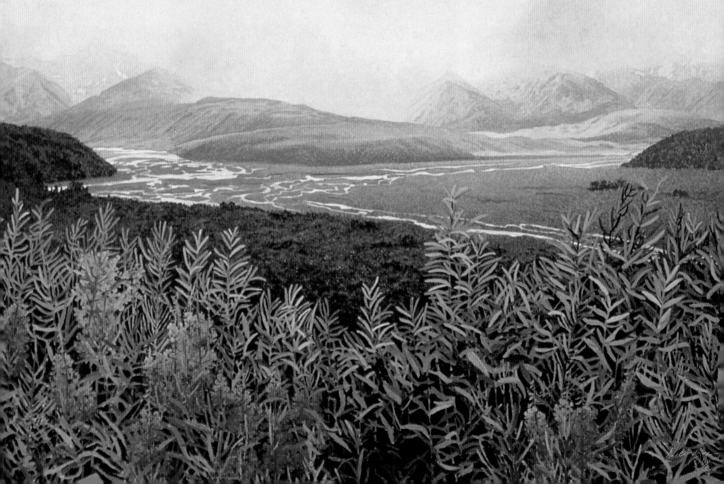

Alaska's Famous Fireweed

I grew up in the dry, Southern California climate, and my paintings tended to reflect the bland monochromatic palette of the land. When I first arrived in Alaska, the colors of the landscape and the purity of the air—I was told you could see 100 miles—overwhelmed me. I wasn't aware that Alaska had changed my palette, however, until someone from San Diego commented that my paintings had become so brightly colored. I don't think she believed an entire valley could be pink!

◄ *Denali Valley* The highways in Alaska are bordered by fireweed all summer long. Sometimes the clearings that flank each side of the road look like Christo sculptures: long pink blankets that stretch as far as the eye can see. I've also seen fireweed in wilderness settings that look professionally designed and in areas where nothing else will grow. This wildflower reminds me of my daughter Tawny who has immeasurable strength, is smart and tough, and is gentle and beautiful at the same time.

18" x 24" acrylic

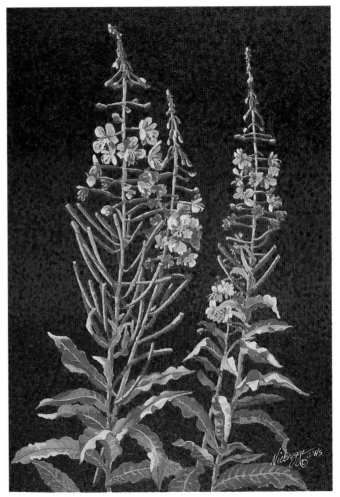

I Love Fireweed

12" x 17" acrylic

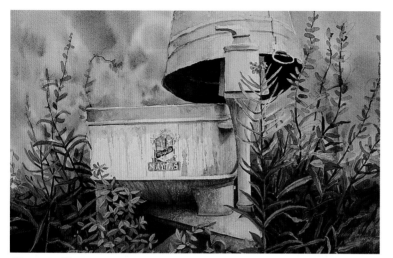

Out to Pasture 15" x 22" watercolor

◀ I combed the fields and woods of the historic town of McCarthy, looking for unusual or appealing subjects to paint, when I found an old Maytag wringer washer abandoned behind a pile of rubble and hidden by fireweed. Several years later I painted *Out to Pasture,* and a McCarthy resident who happened to see it told me that the old washers are hard to come by and are highly prized over doing laundry by hand with a tub and washboard. Everyone in McCarthy was anxious to know where to find this one.

▶ I cannot remember how many times I walked by this abandoned building and found nothing of interest to paint until the day I saw fireweed growing in front.

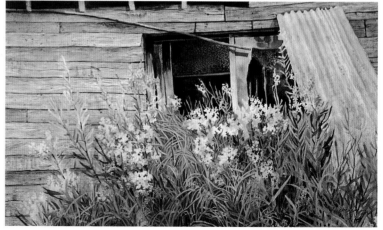

Window Garden 22" x 30" watercolor

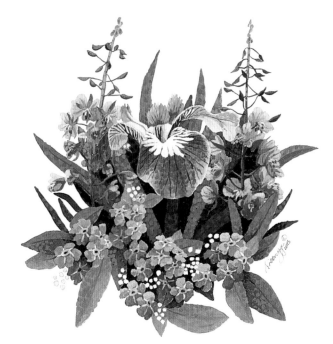

Iris, Forget-me-not, and Fireweed 16" x 18" acrylic

▶ I found this wonderful cache in front of a wilderness lodge on the Denali Highway. The high rise cabin, as I call it, was sitting in a barren dirt clearing used for parking; I added abundant fireweed all around the base as I worked on my painting. Upon seeing the finished painting, the owners of the cache commented that they had forgotten how charming the fireweed used to look and that they were going to replant some.

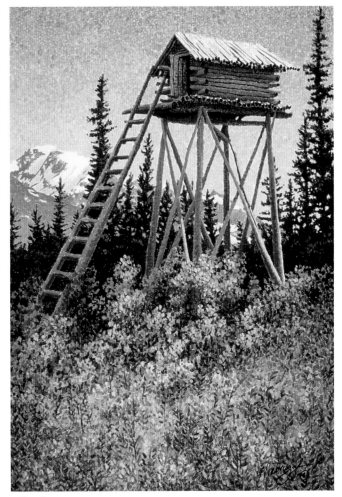

Cache 12" x 18" acrylic

Fire and Ice 10" x 14" watercolor/acrylic

▲ I am especially proud of *Fire and Ice* because it comes from a photo taken by my son, Ron. Copying photos is normally a big no-no for me; it's a violation of one of my highest ethics. I use photos only as reference tools and prefer to build a painting from scratch following the rules of good composition: light, shadow, perspective, harmony, balance, tension, and pattern. To honor my son, I did not change a thing in his flawlessly composed photograph.

◄ I will never forget the rainbow I saw while flying my airplane. Sunrays came through a hole in the clouds at the perfect angle and caused three concentric rainbows to form around the propeller: an awesome sight.

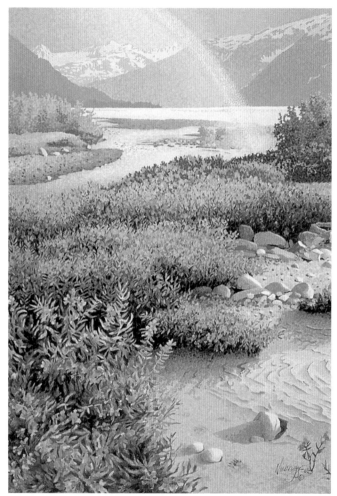

Rainbow of Color 18" x 25" watercolor/acrylic

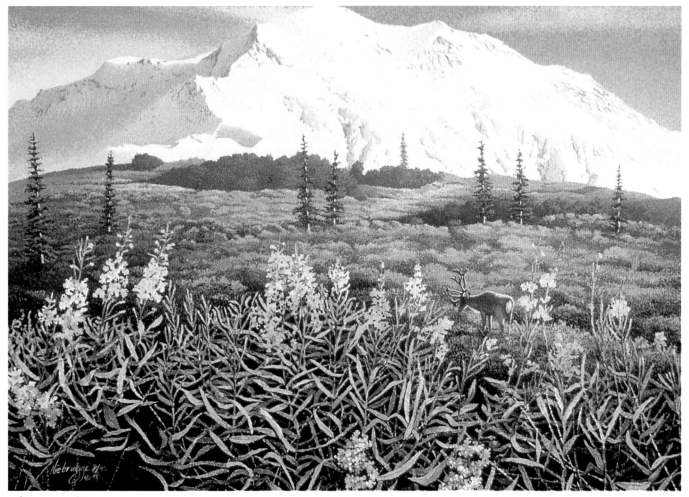

Alaska's Legacy

22" x 30" watercolor/acrylic

► Each time I visit the historic sites of McCarthy and Kennicott, I either discover a new subject or see an old one with a new perspective. The ancient office located next to the fourteen-story mill building is the only log building at the Kennicott site. When the hillside directly below is choked with blooming fireweed, it looks like a landscaped flower garden.

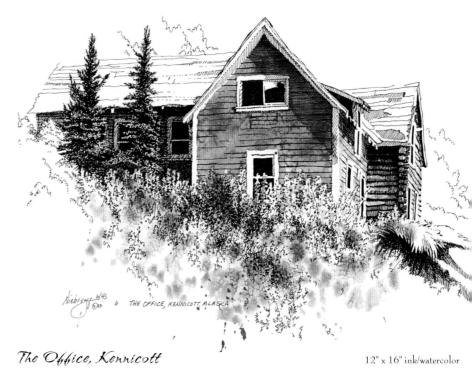

THE OFFICE, KENNICOTT, ALASKA

The Office, Kennicott 12" x 16" ink/watercolor

White Fireweed 14" x 20" acrylic

◄ Dwarf fireweed, the stubby cousin of common fireweed, carpets the sandy riverbed below my studio during the summer with its magenta-colored blossoms. On one of my daily walks, I was startled to see a very rare, white fireweed in the midst of a field of pink ones. After photographing the plant, I marked the location with twigs and rocks so that I could easily find it again. When I returned a week later, I found, to my dismay, that all the petals had fallen for the season and it was impossible to identify the white plant from the others!

Triptych

A native Alaskan who grew up in the Bush told me she thought of fireweed as just a tall, pink flower until she saw my fireweed triptych painting. I remember her pride as she explained how my paintings have inspired her to study wildflowers. Her story touched me deeply. I realized that the artist sees the world differently and brings a new perspective to the ordinary things in everyday life.

Bloom *Transition* *Seed*

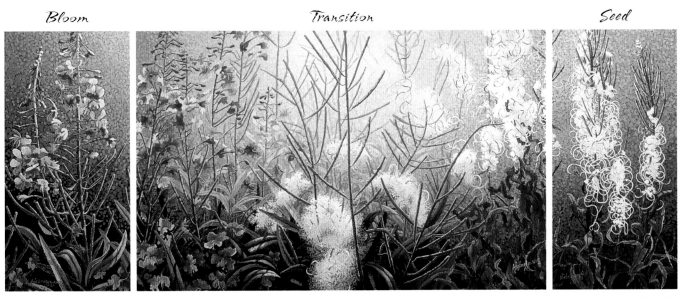

8" x 17" acrylic 29" x 17" acrylic 8" x 17" acrylic

Wildflowers, Wildlife, Wild Places

For years I painted lupine in my landscapes without knowing its name. People told me how much they loved the lupine in my paintings, and I saw it as simply adding dots of purple to the foreground. From the day I discovered a lupine-filled meadow in Ninilchick where the plants were nearly over my head, however, my landscape painting reached another level of maturity.

Lupine 14" x 20" acrylic

Meadow Edge 22" x 30" watercolor/acrylic

It seemed like a good idea to ask our friend, a well-known pilot and guide, to fly Bob, Ron, and me to the top of a ridge in a Super Cub and drop us off for the day. We planned to hike down and photograph the spectacular views. It didn't seem important that Bob and I were both out of shape and didn't have decent hiking boots. We watched Dall

sheep graze, saw incredible vistas, and discovered the moss campion: a gorgeous, pink wildflower that grows in dry, rocky, alpine conditions.

The hike back started out fine. Then my knees began to throb from the pressure of each step down, followed by my calves tightening into balls of stone and several hot spots on my heels and toes turning into raw wounds. We had gone far enough down the ridge, however, that I told myself I could make it; I just needed to tough it out. We reached the bottom just in time: I silently cursed the wilderness and the hot sun, and I didn't give a damn about moss campion wildflowers. Unfortunately, it turned out we had only reached the halfway point. Many hours later we hobbled home, me barefoot and carrying my boots, and Bob near exhaustion. I started a fitness campaign the next week.

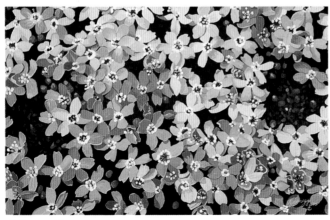

Moss Campion 14" x 20" acrylic

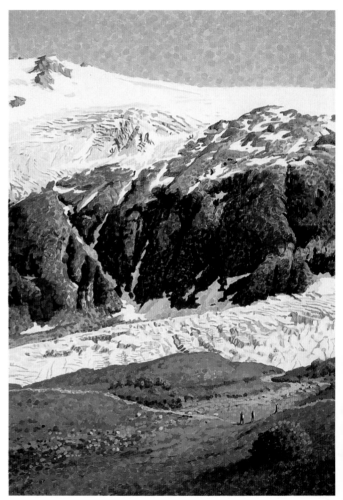

Glacier Trail 16" x 20" acrylic

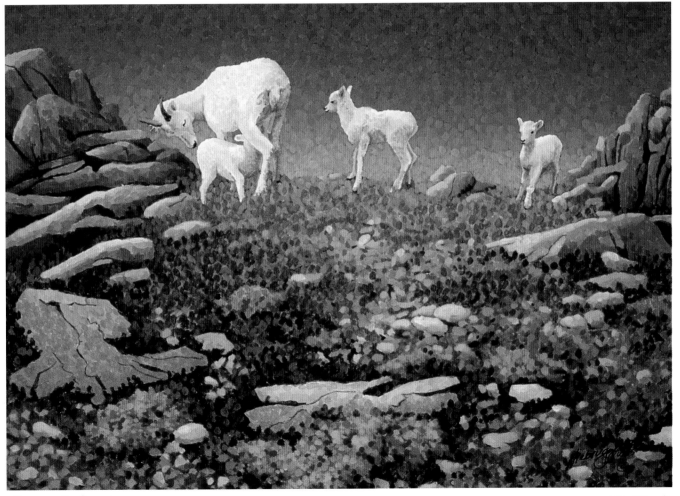

Ewe with Lambs

14" x 20" acrylic

▶ I stood on a bridge in Denali National Park and contemplated shadows cast by the sun on the landscape. Out of the corner of my eye, I caught a glimpse of movement on the road. Tensing and turning slowly, I saw a wolf coming straight toward me on the bridge. My heart pounded wildly as I stood motionless and weighed my options for escape. I was torn between two choices: jump from the bridge, bash myself into pieces, and drown, or have my throat ripped out by vicious, rabid, wolf fangs. He continued across the bridge, passed within ten feet of me without acknowledging my presence, and wandered down the road and into the woods.

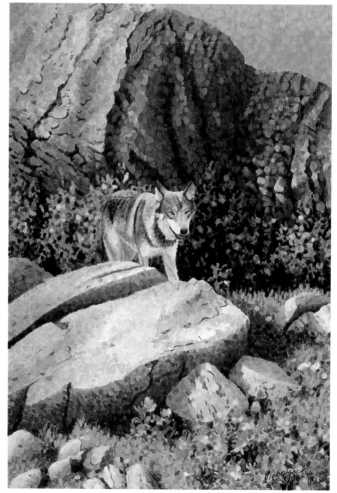

Wolf and Roses 14" x 20" acrylic

▶ Red fox kits start to venture from their dens during midsummer. Curiosity overtakes caution in the course of their early explorations, and the young fox appear tame. One afternoon the fuzzy little guy in the painting, *Poppy Patch Fox,* came out of the foliage to check me out. I sat quietly on the ground for one of the finest hours in my life while he alternately backed away and approached me, lay down close to me, and chased leaves and pounced on twigs.

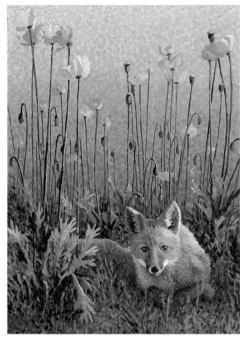

Poppy Patch Fox 14" x 20" acrylic *(See detail page 26)*

▶ I knelt with my head bent over the camera and concentrated on photographing cotton grass until I heard sounds in the nearby bushes. Looking up, I saw a grizzly bear feeding on the opposite bank of the small pond that separated us. Time was suspended as I carefully, silently, and inelegantly retreated to the safety of my truck. What seemed like an hour actually took seconds.

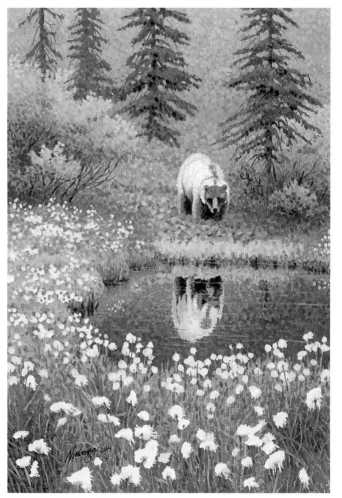

Cotton Grass Bear 14" x 20" acrylic

▼ Large patches of the tundra flower frigid arnica share the rocky slopes with caribou near the Eielson Visitor Center in Denali National Park.

▶ The red columbine is one of the best-loved wildflowers in Alaska, and many people cultivate them as an important part of their flower gardens. Red columbine bushes in the wild, laden with blossoms, are a sight to behold. The petals look like miniature crowns, and the red and yellow coloring gives the plant a saucy look.

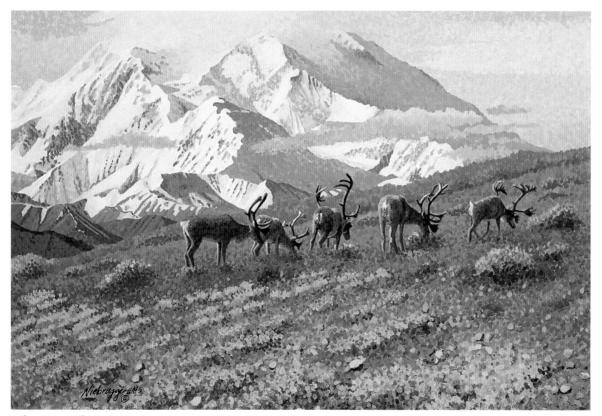

Caribou Country

14" x 20" acrylic

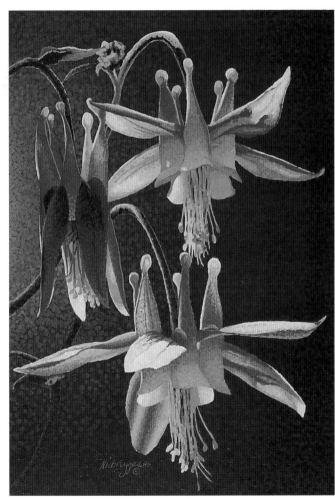

Western Columbine 14" x 20" acrylic

Wagon Wheel Columbine 10" x 14" ink/watercolor

33

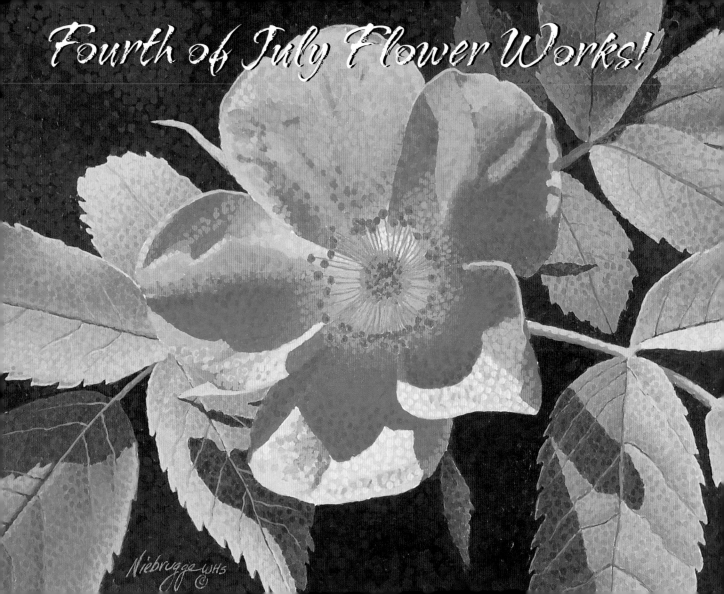

Fourth of July Flower Works!

Niebrugge WHS ©

The first time I found a chocolate lily it was early in the morning. The lily nodded its head, and I assumed it was waiting for the sun. I wanted to paint the flower with its head up and show its colorful pistil and stamen against the rich brown of the petals, so I waited. At noon the head still drooped. One o'clock, two o'clock, still no change. I decided the lilies weren't mature enough to track the sun. A week later I came back. While the lilies had grown taller, the heads looked the same. Consulting my field guide, I was embarrassed to find a description referring to the "characteristic drooping head" of the chocolate lily. Oh, the importance of knowing your subjects!

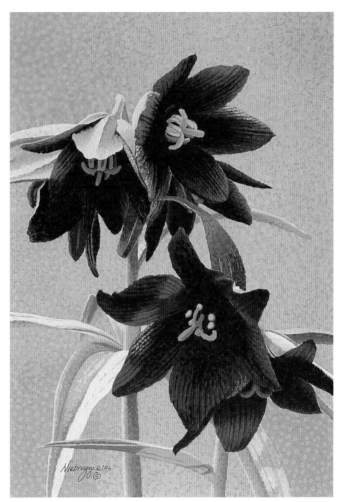

Mixed Bouquet 14"x 18" acrylic

Chocolate Lily 14" x 20" acrylic

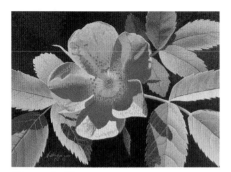

Prickly Rose 14" x 20" acrylic

◄ The prickly rose grows abundantly in my yard; I cultivate them for their lovely smell and delicate blooms. In the latter part of August, the plant forms a fruit called rose hips, and the thrifty, do-it-yourself homemaker uses them to make jelly and jam. My second summer in Alaska, even though I had never made jelly or jam of any kind, I decided to make rose hip jelly. My daughter and I modified a strawberry jelly recipe, and we gathered bags of rose hips. They looked quite strange for a fruit: not very soft, with stringy tails. We washed them, pulled off the tails, and simmered them until they were soft. Then we sweetened them and added pectin for jelly. It was the worst-tasting, pulpy, seedy mess I have ever made. Later, we discovered we were supposed to strain out the skin and the seeds after they were boiled.

► Below my studio in the Matanuska Valley is a riverbed where I like to walk. One of my favorite places is a spot along a slow-moving stream where the Eskimo potato flourishes, the nearby mountains are often reflected in the water, and waterfowl and other critters congregate; it's a quiet and private place.

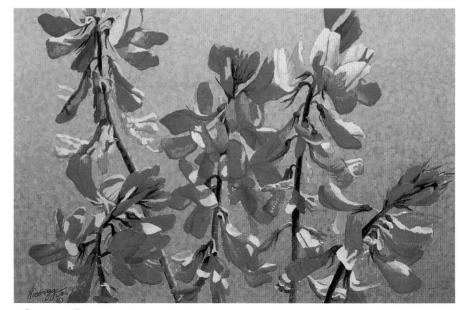

Eskimo Potato 14" x 20" acrylic

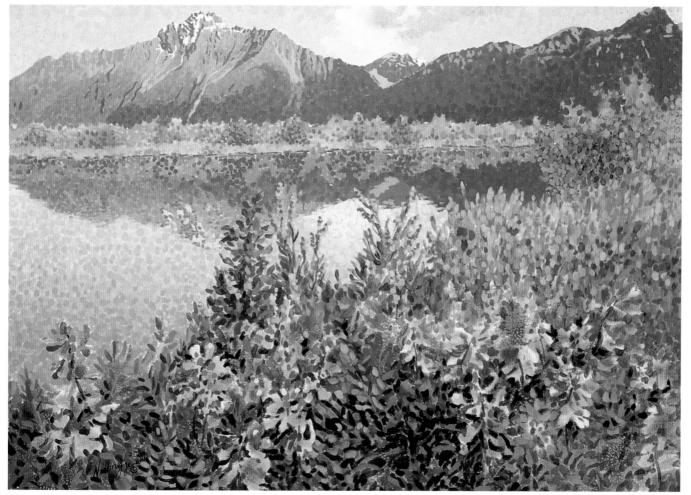

Quiet Riot

22" x 30" watercolor/acrylic

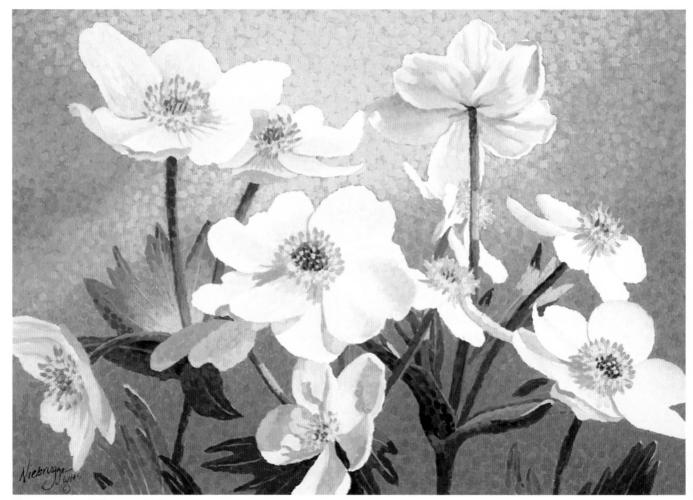

Narcissus-Flowered Anemone

14" x 20" acrylic

◄ Many varieties of small, white flowers grow wild in Alaska. All of them have white petals with yellow centers and, at first glance, look alike. When I studied them more carefully, however, I found the alp lily, star flower, and mountain avens bloom in alpine habitat; the grass of Parnassus, narcissus-flowered anemone, and windflower grow in meadows; and the tall sandwort and prickly saxifrage grow in rocky areas.

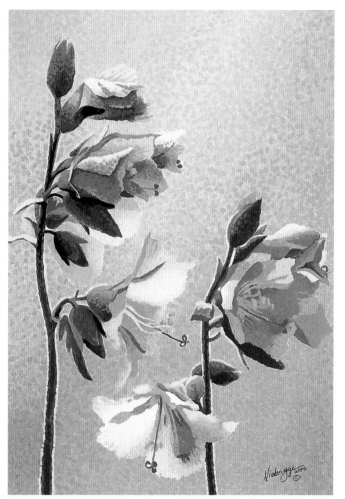

Tall Jacob's Ladder　　　14" x 20" watercolor/acrylic

◄ Not surprisingly, this wildflower took on additional meaning for me the more I learned about it. I sell note cards that feature my wildflower paintings, and *Tall Jacob's Ladder* is a popular card. After several people told me that they purchased this particular card because of the flower's spiritual significance, I became curious and did a little research. In the Bible, the story of Jacob is told in the book of Genesis, chapter 28, verse 12: "And he dreamed that there was a ladder set up on the earth, and the top of it reached to heaven; and behold, the angels of God were ascending and descending on it." In Palmer, above the Pioneers' Cemetery gate, there is a miniature ladder symbolizing the ladder to heaven. That ladder has special meaning for me now and, more than once, has moved me to tears.

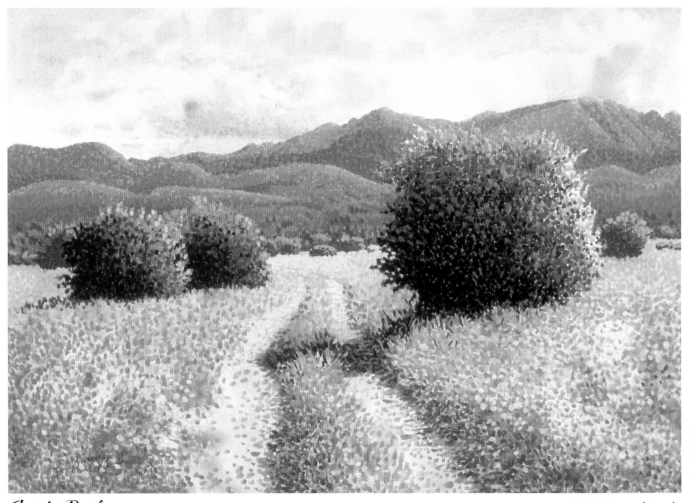

Country Road

22" x 30" watercolor/acrylic

◀ Some places in Alaska look like they belong anywhere in the world. These are the kind of roads I love to explore because I never know what lies ahead. Sometimes they end abruptly, go on for miles until they become a single narrow path, or come to gullies and streams that are impassable. They always hold a promise.

▼ I love the deep purplish-blue colors of the monkshood and larkspur. I love the shape of the monkshood blossom. I love the tall, flashy, attention-getting stalks of flowering larkspur. I love seeing both of these perennials growing wild and free in the woodlands and meadows of Alaska. I hate that both of these plants are poisonous!

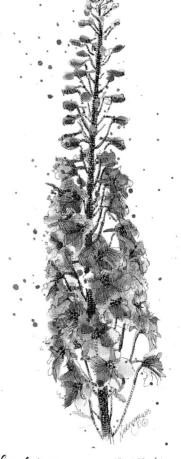

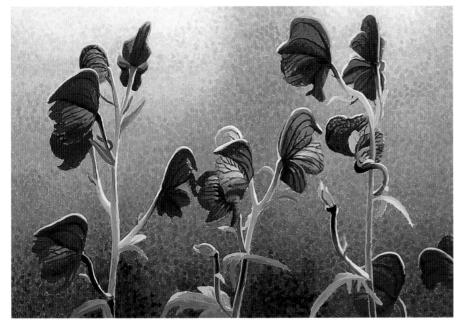

Monkshood 14" x 20" acrylic

Larkspur 8" x 16" ink/watercolor

▼ Wild geraniums are not found much farther north than Nenana or Delta, and I don't remember seeing many while living in the Copper River Basin. In contrast, the Matanuska Valley, with its ideal growing conditions and its abundance and variety of wildflowers, opened up a whole new world to me. Wild geraniums flourish in the valley, and their fragile blossoms shimmer nearly transparent when backlit by the sun.

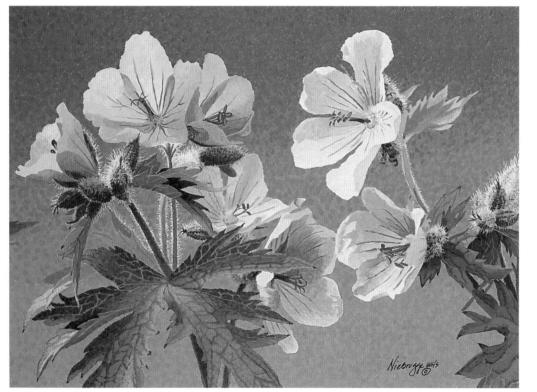

Wild Geranium

14" x 20" acrylic

► Some of the prettiest sunsets anywhere in Alaska can be seen from the Wasilla Fishhook Road. During a particularly brilliant summer dusk, I saw light not only illuminating the mountains, but also streaking across the fields and turning them into dazzling strips of chartreuse and dark green. As I painted the colors of the pastures, I thought of Psalm 23: "The Lord is my shepherd; I shall not want. He maketh me to lie down in green pastures: he leadeth me beside the still waters. He restoreth my soul. . . ."

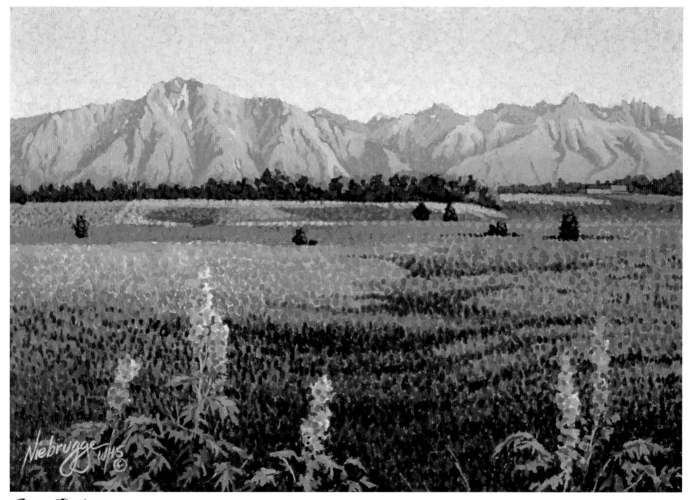

Green Pastures

8" x 12" acrylic

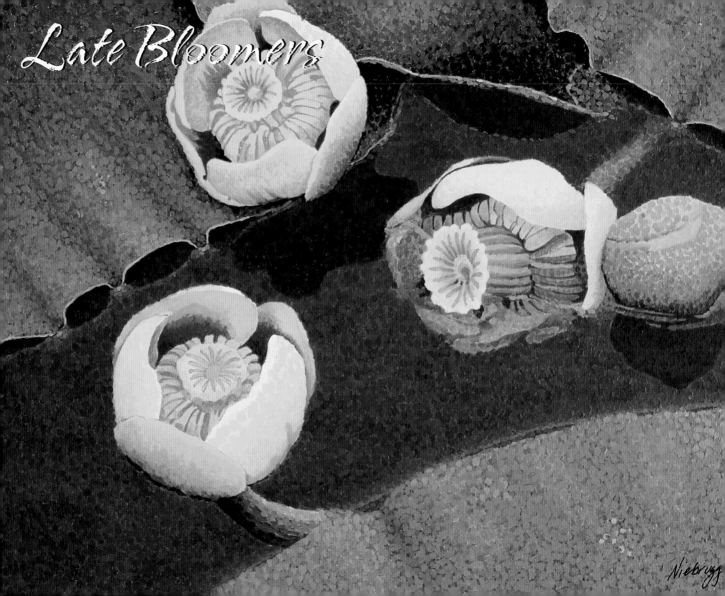

Late Bloomers

Niebrugg

When I got ready to paint the yellow pond lily, I needed to study the big leaves up close, so I convinced Bob to walk with me to the local pond and bring back a few. We hiked a mile to the pond and realized we needed waders to reach the leaves. We walked home, got waders, and returned. Then we discovered the leaves were anchored to the bottom as if with lead weights. Following a hilarious struggle and getting soaked to the core, we returned home, victorious, with two big leaves. I kept the leaves in a rarely used bathtub while I worked on the painting. Several weeks after finishing the painting, we returned from a trip and were greeted with a nauseating stench throughout the house. Searching everywhere for the cause, we found the forgotten yellow pond lily leaves moldy, slimy, and rotting in the bathtub!

◀ *Yellow Pond Lily*　　　　14" x 20" acrylic

▶ A few years after the formation of the Wrangell-St. Elias National Park, I gladly accepted the honor of becoming the very first Artist in Residence. I was surprised to learn during my tenure that the Copper River Basin was one of the largest nesting areas in the nation for the exquisite trumpeter swan. One time I served as a volunteer and helped with swan inventory. We flew a grid pattern in a small airplane and counted the swans while they nested.

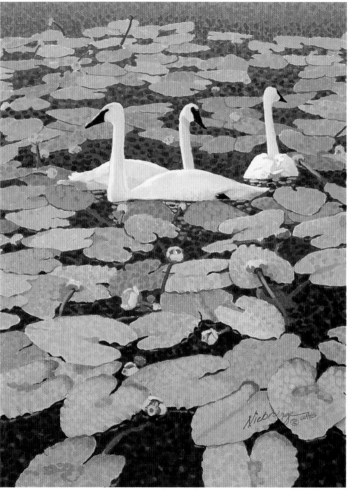

Pond Lily Swans　　　　12" x 16" acrylic

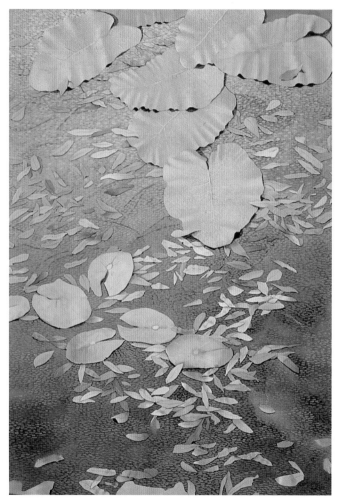

Floating Leaves 22" x 30" watercolor

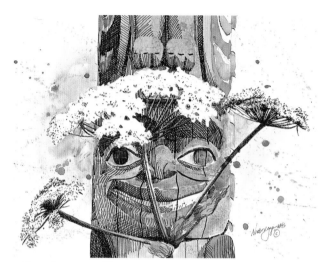

Cow Parsnip Totem 10" x 14" ink/watercolor

▲ For years I called this wildflower "the big plant with cauliflower-shaped blossoms." Many times I have found myself over my head in cow parsnip, which varies in height from five feet to eight feet.

▶ The first time I saw this flower, it reminded me not only of the sunflowers in paintings by the Dutch postimpressionist painter Vincent van Gogh, but also of how a prehistoric plant might look. When I was a child, I loved the work of van Gogh. Beach Fleabane was deliberately designed to incorporate techniques used by both van Gogh and Seurat.

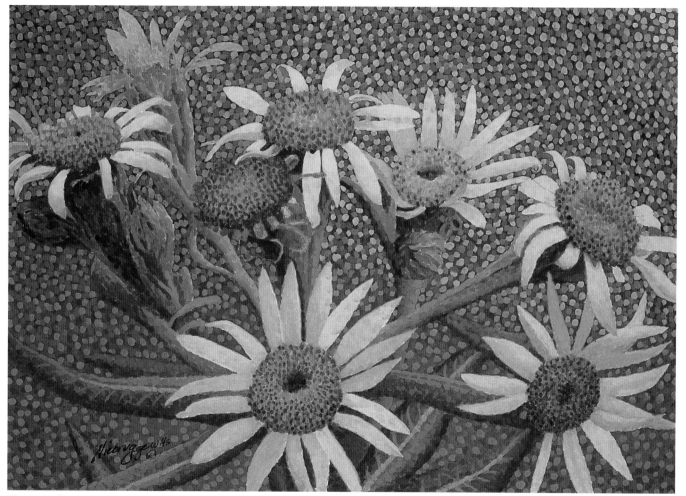

Beach Fleabane

14" x 20" acrylic

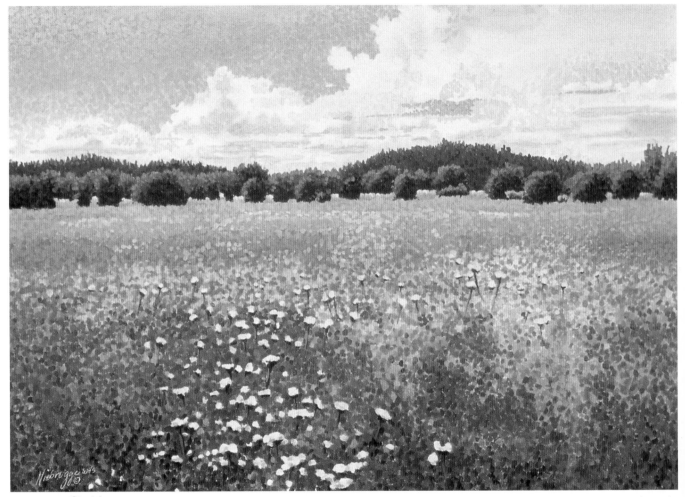

Yarrow Field

22" x 30" watercolor/acrylic

◀ In San Diego County, I would often pack up my canvas, easel, and paint and spend all day painting on location, or *plein air* as the French say. The mild and consistent weather made it a joy to paint on the spot. When I arrived in Copper Center, I was armed and ready with all of my outdoor painting gear.

I would set up early in the morning in a field full of wildflowers. Within minutes I was swarmed with mosquitoes. I quickly learned the dos and don'ts of industrial strength mosquito repellent: If you get it on your hands, anything plastic you touch will melt. Paintbrush handles, my camera, water bottle, sunglasses, and the steering wheel of my car suffered catastrophic meltdowns. Learning to use repellent, however, was just the beginning. Once repelled, hundreds of mosquitoes hovered inches away from my face and eyes. Concentrating through a screen of moving insects took nerves of steel; extracting them from the wet paint on a canvas was another story. If you tried to remove them when they landed and were still struggling, you risked ruining delicate passages of paint. If you waited until the paint dried, you risked leaving body parts—wings and legs— permanently embedded in the work.

Mosquitoes were a minor distraction compared to the regular and predictable afternoon wind. No matter how many bungee cords were tied to my easel and anchored to rocks, the wind managed to catch the canvas and send it sailing like a kite. Then there was the matter of twenty hours of sunlight. For me, a good painting is two-thirds light and one-third subject. The low, shadow-casting light of early morning or late evening is the best, which meant I either had to set up and start painting by three o'clock in the morning, or stay out until eleven o'clock at night. I will spare you the details about the rain, but suffice it to say that it managed to rain just a little bit every single day. I quickly learned to use a camera and become a studio painter.

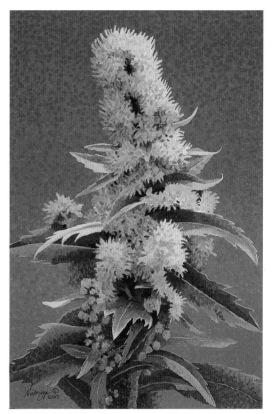

Elegant Goldenrod 14" x 20" acrylic

Dogwood Berries 10" x 14" ink/watercolor

Our family didn't stay in the two-room log cabin in Copper Center for long; the romance faded quickly against the hard work of heating with wood and hauling water. First we moved into a single-wide mobile home, then rented a double-wide large enough for me to set up a studio in the family room. It was a dream house situated along the beautiful Klutina River with large windows that framed views of Mt. Drum and the Wrangell Mountains from the studio; we moved in just as the dogwood blossoms faded and berries appeared. I placed my drafting table facing the window and the view, and I saw myself painting the landscape throughout the four seasons from that spot. One winter morning, I opened the curtains to find the surface of my studio window, and every window in the house, covered with frost. I couldn't believe I had to look at

the inside of a freezer all winter instead of my beautiful view. After some investigation, we realized our problem was single-pane windows.

Clinging to the spirit of a true "cheechako" (a newcomer to Alaska without experience in the Alaska ways), I used duct tape and attached Visqueen over all the outside windows to add a layer of insulation. I defrosted the glass inside the house with warm air by reversing the vacuum cleaner, and I mopped up the water and wiped the windows dry. *Violá!* The Visqueen sort of "softened" the view, but it seemed like a good compromise. The next morning found the windows again covered with frost and all of the Visqueen peeled loose from the metal siding and heaped on the ground. It was a long, disappointing winter in my studio: I kept the drapes closed over the frost and turned my drafting table so my back was towards the window. I'm not sure, but this experience may have contributed to my negative attitude toward painting winter scenes.

▶ I always enjoy looking at the hand-hewn, fitted corners of log construction or the contrast of wild plants against weathered logs.

Rattlebox 12" x 14" ink/watercolor

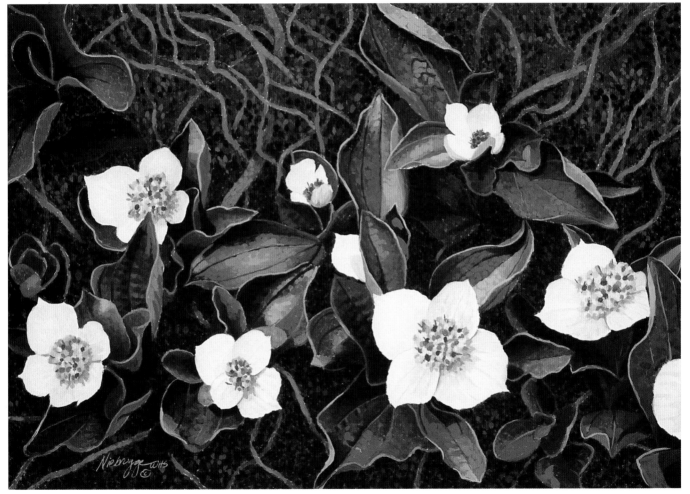

Dogwood

14" x 20" acrylic

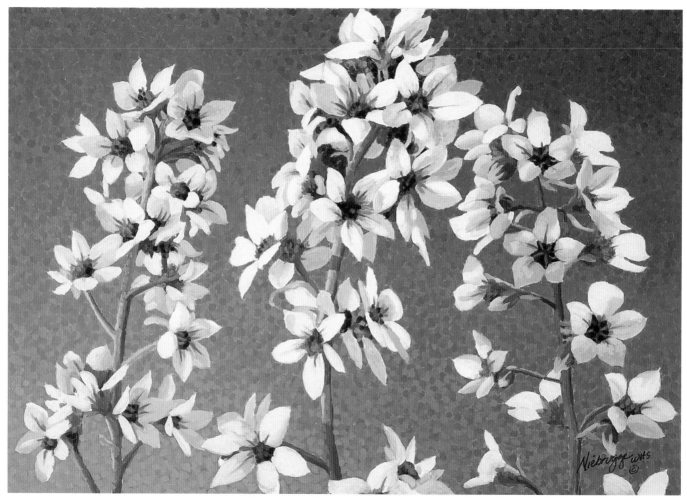

Bear Flower

14" x 20" acrylic

▶ I saw a meadow full of pearls glistening in the sun and fell in love with the grass of Parnassus and its pearl-shaped bud held gently in a nest of tiny leaves

◀ and ▼ Bear flowers grow in Denali National Park and are about four feet tall and gorgeous. Bob and I learned firsthand that bears feed on the blossoms when we watched a grizzly sow with two cubs search for their dinner. Eventually they came to a meadow lush with the stately white blossoms of the bear flower, and the three of them fed as if they had found a cache of hamburgers and french fries!

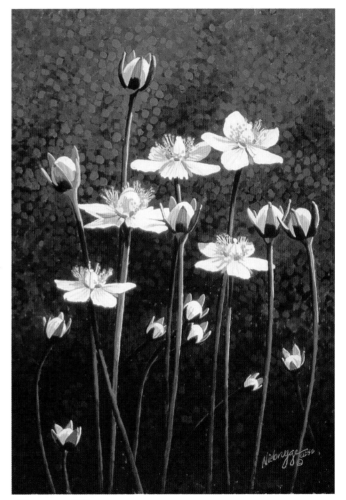

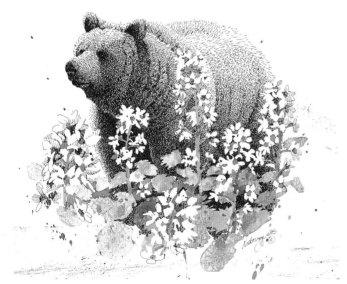

Bear and Bear Flower 12" x 13" ink/watercolor

Grass of Parnassus 14" x 20" acrylic

September in Alaska

*I*did not understand how stunning fall could be until I witnessed it in Interior Alaska. The spectacular color of wildflowers ends in mid-August, but taking its place is foliage changing from green to red, orange, or yellow. Berries emerge everywhere. Treasures are uncovered and become artfully framed by the colorful leaves.

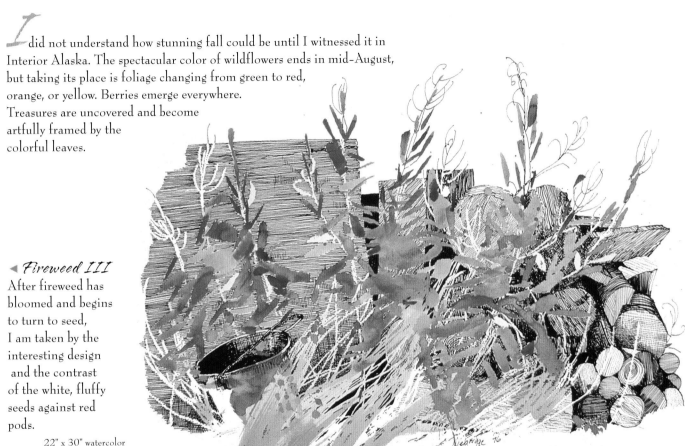

◄ *Fireweed III*
After fireweed has bloomed and begins to turn to seed, I am taken by the interesting design and the contrast of the white, fluffy seeds against red pods.

22" x 30" watercolor

Fire in the Woodpile

20" x 24" ink/acrylic

55

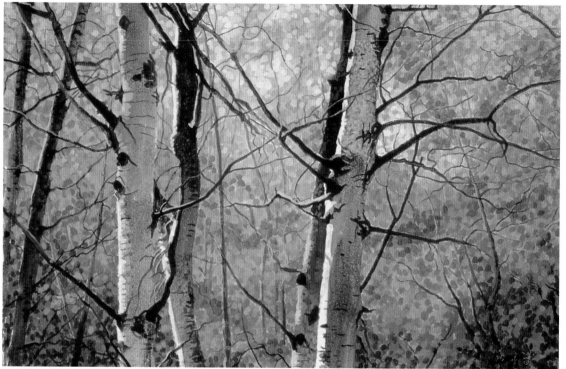

Paper Birch

15" x 22" watercolor/acrylic

▲ A birch forest surrounded my studio in Copper Center and lined the edge of the Copper River. Every day I would walk down the dirt trail to the river, examine the fish wheel, visually measure the height of river, and look for bald eagles. I inspected the ground, plants, and trees; checked out the sky and the clouds; and watched for critters. Satisfied that all was well in my world, I would return home and resume painting. Through all of my memorable walks in this forest, the best ones occurred in the fall when the rich colors filled my senses.

▶ I worked on Mile 60 Richardson for several years. Preliminary studies began one rainy day on location near Tiekel while I sat inside my car creating watercolors to depict the short fall season. Several years later I started to paint the scene and found, by combining acrylic with watercolor, I could capture the brilliant glow of birch trees against the dark, twisted spruce that dominate the region.

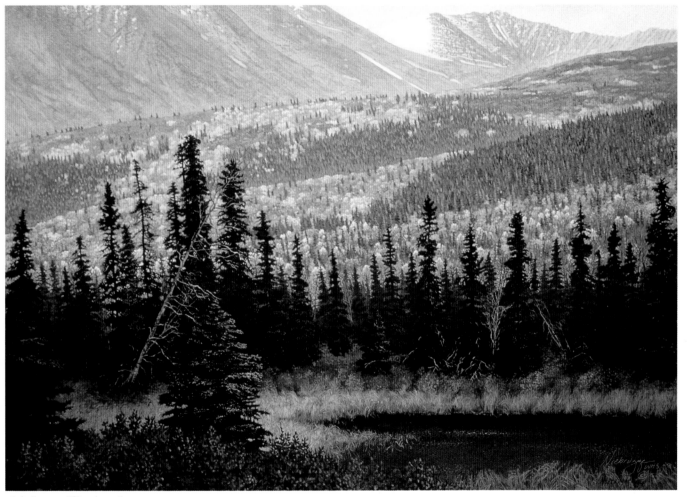

Mile 60 Richardson

22" x 30" watercolor/acrylic

Fireweed I 9" x 12" acrylic/collage

◄ Fireweed colors are intense through all stages of growth. Pink blossoms rule the green-tinged landscape during June and July while vermilion, cerise, and russet leaves complement August's color palette.

► When the fireweed go to seed, it is time to feast on frost-sweetened, wild blueberries. To pick the low-growing berries, we crawl on hands and knees, gathering and eating at the same time, our faces, teeth, hands, knees, and butts stained purple from wallowing in the juicy fruit.

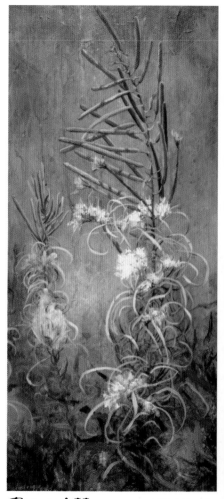

Fireweed II 18" x 36" acrylic

▼ This tundra above the tree line near Tangle Lakes is so spectacular during the fall that it appears surreal. On a cloudy day, the magenta hue dominates and becomes fluorescent against the neutral gray backdrop. I painted *Magenta Marsh* in memory of a day with water of liquid silver and intense color everywhere.

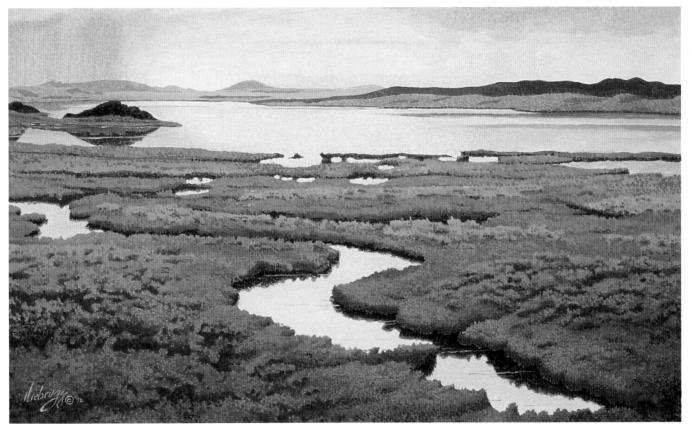

Magenta Marsh

16" x 24" acrylic

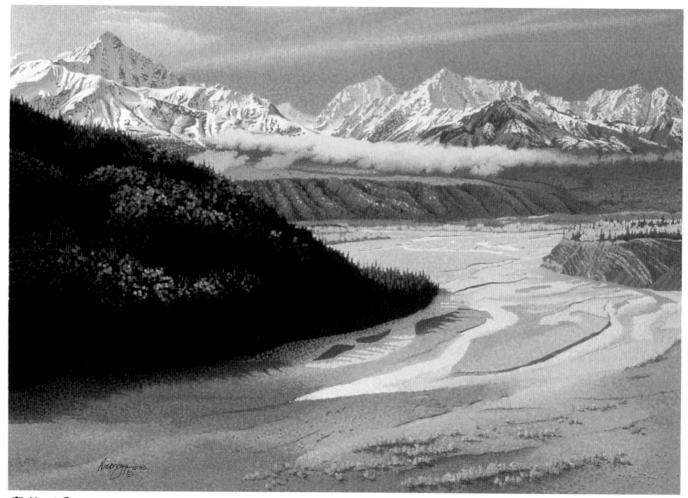

Fall of Snow

20" x 28" acrylic

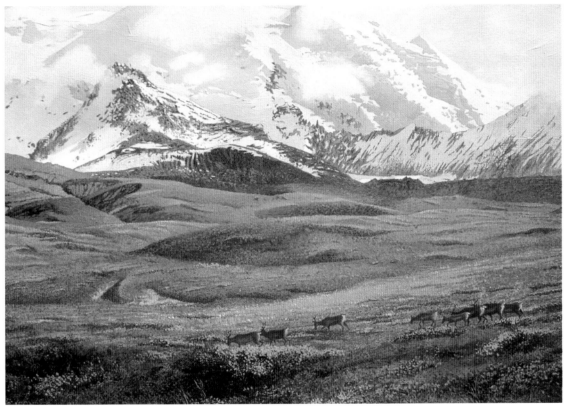

Mt. Drum; North Face

18" x 24" watercolor

◀ Before the first snow, I enjoy exploring for the short time that the landscape is predominately brown. Walking on the tundra is easier without the tangle of leaves and tall plants, and new horizons open up that were previously hidden by dense foliage. One day while watching caribou meander along the foothills of the Wrangell mountains, the cloud cover lifted and exposed the magnificent north face of Mt. Drum; it took my breath away.

◀ Driving the Glenn Highway, I saw fresh snow on the fall-tinged panorama and was torn by differing emotions: sadness that autumn was almost over, and anticipation of the aura of winter.

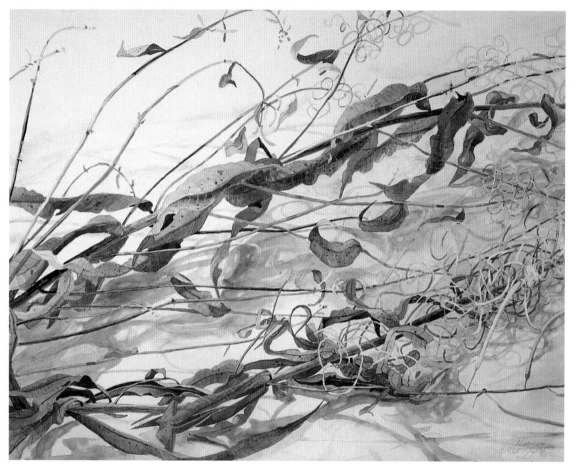

Fireweed IV

15" x 20" watercolor

◄ My fireweed fascination continues to the finale. I see grace and dignity in twisted stalks with curled parchment leaves skewed in random directions: distinctly different even in death.

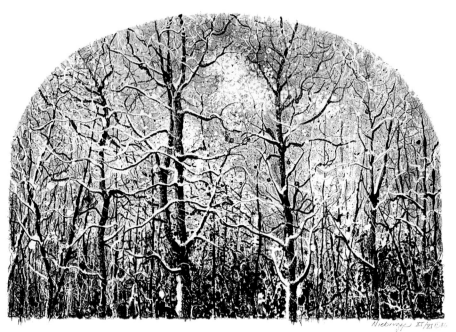

Birch in White 16" x 20" stone lithograph

▲ To capture the winter view through my studio window in Copper Center, I deliberately limited my palette to black and white. Birch in White was created with crayon, pencil, and tusche (a material containing grease and black pigment used in lithography) and sketched directly onto a slab of limestone. To make an impression of the image, I inked the stone, covered it with a sheet of rag paper, and applied pressure with a hand-cranked press. This method, called stone lithography, has the characteristic irregularities associated only with hand-pulled prints and best captures the feeling and mood of birch trees in winter.

▼ Winter in Interior Alaska is as brutal as it is awesome. Nothing equals the splendor of hoarfrost coating the branches of leafless trees, spruce trees shaped like irregular white mounds, darkness illuminated by aurora borealis, and the extraordinary silence of frozen rivers.

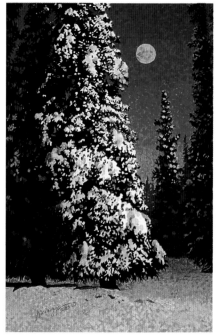

Midday Moon 10" x 16" acrylic

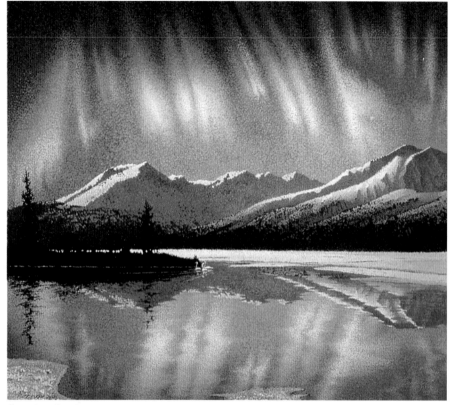

Night Light 28" x 30" watercolor/acrylic

Insulated by snow, wildflowers lie dormant and wait for spring. I look forward to finding and learning about new wildflowers and bringing them to life on canvas to share with you. It has been a magnificent, interesting, and informative journey.